KU-711-876

DRAGONS
TRUTH, MYTH AND LEGEND

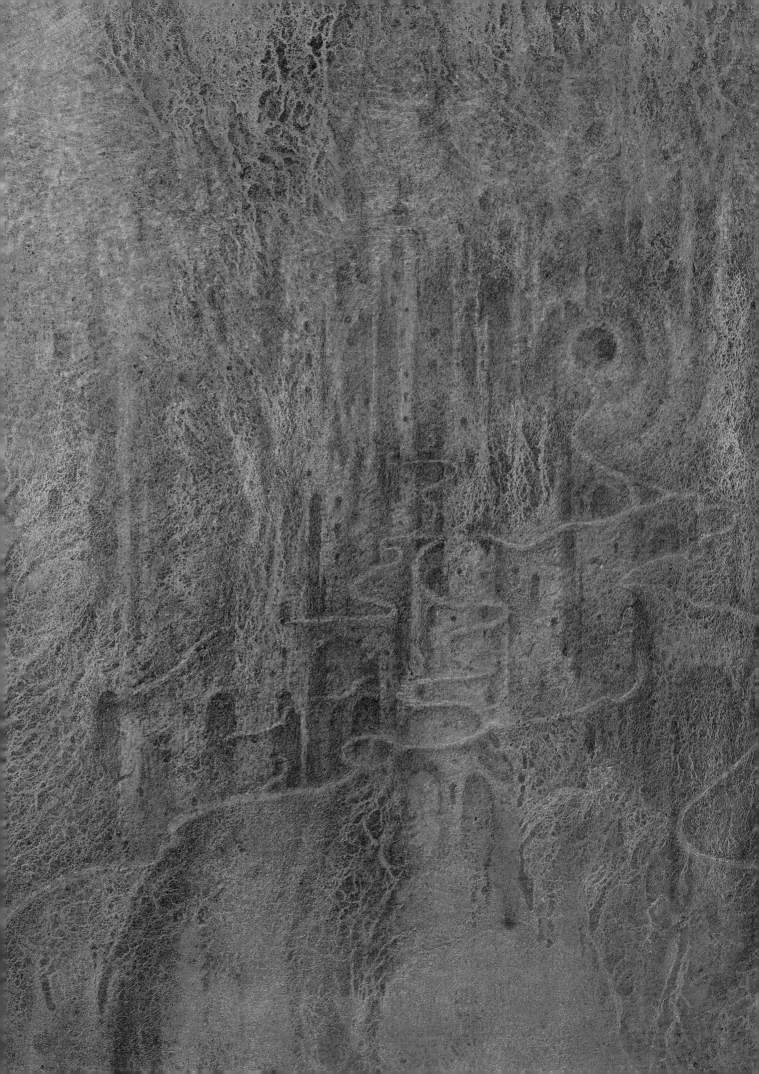

To the winged white Knight
who saved me from the Dragon
D.P.

For Carole, Louise, Katie, Emily,
Amelia and Elizabeth Alice
W.A.

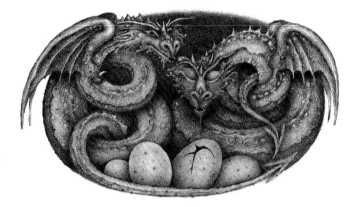

First published in Great Britain in 1993 by Chrysalis Children's Books,
an imprint of Chrysalis Books Group Plc
The Chrysalis Building, Bramley Road
London W10 6SP
www.chrysalisbooks.co.uk
This paperback edition first published in 2005

Text copyright © 1993 David Passes
Illustration copyright © 1993 Wayne Anderson

The moral right of the author and illustrator has been asserted.

All rights reserved. No part of this publication may be reproduced, stored in a retrieval system,
or transmitted, in any form or by any means, electronic, mechanical, photocopying,
recording or otherwise, without the prior permission of the copyright holder.

A CIP catalogue for this book is available from the British Library.

ISBN 1 84458 476 3

Printed in China

2 4 6 8 10 9 7 5 3 1

This book can be ordered direct from the publisher. Please contact the Marketing Department.
But try your bookshop first.

DRAGONS

TRUTH, MYTH AND LEGEND

WRITTEN BY **DAVID PASSES**
ILLUSTRATED BY **WAYNE ANDERSON**

Chrysalis Children's Books

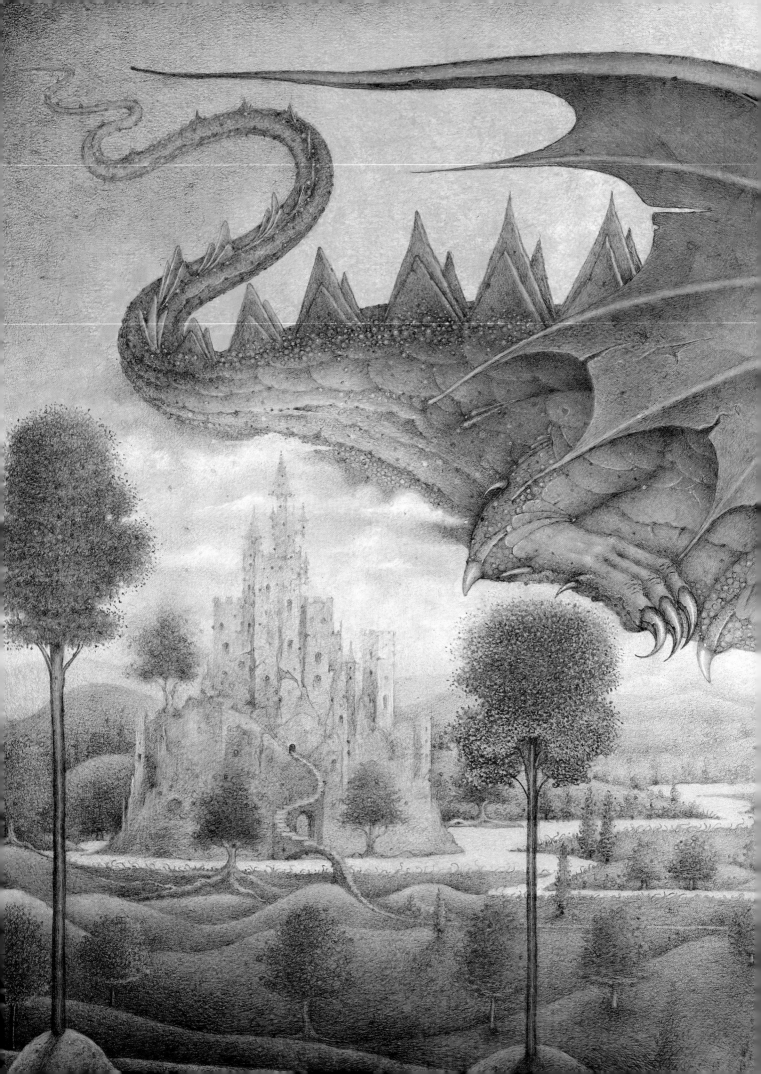

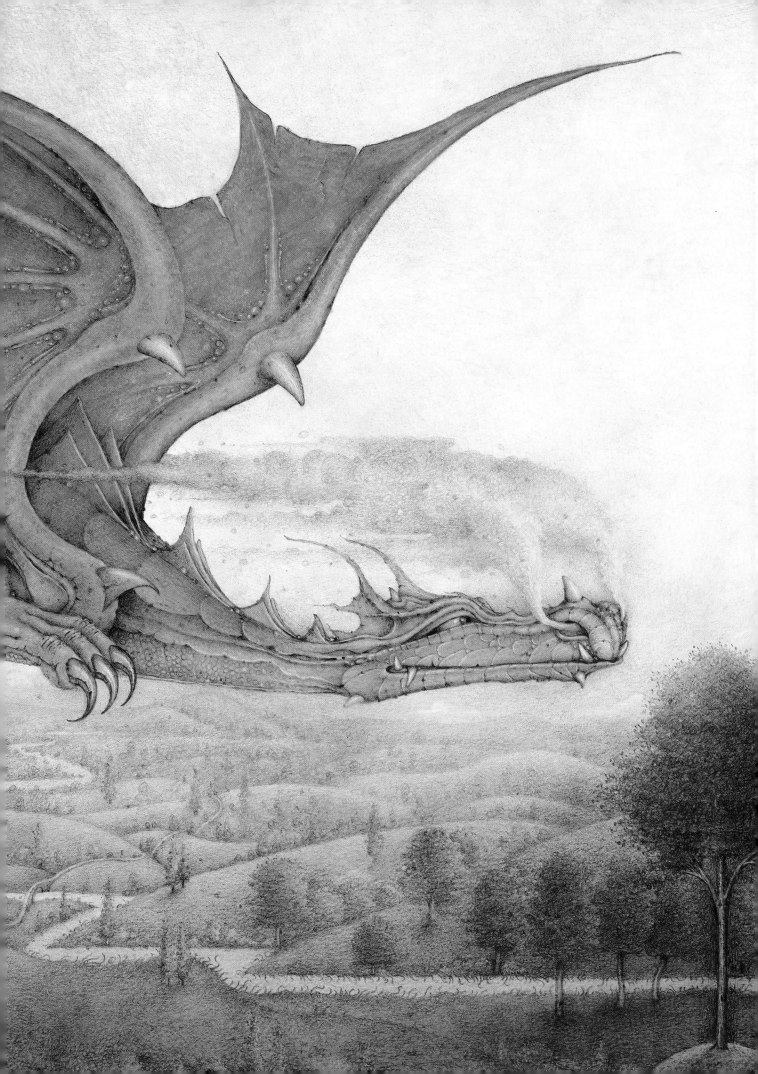

INTRODUCTION

Just a few hundred years ago, sightings of dragons were quite common. Ordinary people saw them; so did kings, knights, archbishops and monks. Learned scholars wrote about them.

But when naturalists began their enormous task of describing and recording all the different types of animals, some people began to doubt the existence of dragons. Today, most naturalists say that dragons never existed. So what exactly were the dragons that people claimed to see?

Of course, it must be remembered that scientific understanding was not the same as it is today. If the sky rumbled with thunder, and was then filled with flashes of lightning, someone might easily report that a dragon had flown by. Or if a wandering traveller saw smoke and fire belching from a distant volcano – what else could it be but a dragon?

Imagine Marco Polo in the thirteenth century, the first European to travel overland to the Far East, coming across a crocodile for the first time. His description – and an artist's rendering made at the time – were exactly like a dragon. And what if someone found gigantic fossilised footprints or dinosaur bones long before the facts about such things were understood? It is no wonder people believed in dragons.

Many present-day lizards look very dragon-like. Most of them are small, but there is a giant monitor lizard that was discovered on the Indonesian island of Komodo in 1912. It grows up to three metres long and stands one metre high. It lives mostly on goats, pigs and deer, but it is known to have eaten humans. Its saliva is poisonous and its breath more foul than any other creature on Earth. It lays eggs and has a forked tongue. Naturally, this lizard is known as the Komodo Dragon. Although it is not the winged dragon of legend, it does give hope to those who still believe that dragons exist!

Frontispiece (pages 6–7)

A **Heraldic Dragon.** These were the dragons that in Western legend held princesses captive, hoarded treasure and were eventually defeated by heroes and saints. They lived in lakes, marshes, mountains and burial mounds. A mature dragon could be between seven and seventy metres long.

CONTENTS

MARDUCK AND TIAMAT

This story of the creation was written on tablets of clay
nearly 4,000 years ago in Babylon.

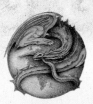

In the beginning there was nothing. No earth, no sky, no gods, no people – only Apsu and Tiamat. Apsu was male, the spirit of fresh water and emptiness. Tiamat was female, the spirit of salt water and chaos. She was a dragon. Apsu and Tiamat together contained the seeds of all living things. Their children were the gods.

One of their children, Ea, had the power to foresee the future. But he was so wild and unruly that Apsu decided to destroy him. Of course, Ea knew about Apsu's plan, because he knew the future. So, to save himself, he tied Apsu up and killed him.

Tiamat was furious. She decided to kill Ea. Ea knew already that Tiamat would defeat him, so he held a meeting with the other gods. They decided to ask Marduck, the most powerful god of all, to fight Tiamat. He alone would stand a chance against her. Marduck said yes, but on one condition. If he won, he would be lord over all the universe.

Marduck and Tiamat prepared for battle. Marduck armed himself with a net and a club, and a bow that fired arrows of lightning. He rode a chariot pulled by four fierce horses, with the four winds to accompany them. Tiamat created a host of horrible monsters to fight by her side – demon lions, savage dogs, scorpion men and eleven glittering dragons.

The battle began. Marduck spread his net to capture Tiamat. Quickly she opened her mouth wide to swallow Marduck. Seeing his chance, Marduck sent one of his winds inside her. It blasted down her throat and blew her jaws apart. Marduck drew his bow and fired an arrow through her gaping mouth straight into her heart. Then he hurled his net over Tiamat's fleeing horde of monsters and put them in chains. Victorious, he split Tiamat's body into two halves. From one half he made the heavens, and from the other he made the Earth. From the blood of one of the chained monsters he made the human race, and put them on Earth to serve the gods.

And so, the world was formed.

INDRA AND VRITRA

The ancient story of Indra and Vritra was sung as a hymn in India for centuries before being written down around 1200 BC. Water was so precious in those times, that the god who controlled it was thought to be all-powerful.

Long ago, before the world was fully formed, Indra was the god of all warriors. He was also the god of nature and the bringer of rain. But he had one enemy: Vritra, a mighty, limbless dragon that crawled over the mountain tops and held back the heavenly waters in his belly. Indra had to destroy Vritra before the waters could flow upon Earth. Indra prepared for battle. He harnessed the Sun for his chariot and thunderbolts for his arrows. Then he charged at his enemy. But Vritra saw him coming and attacked first. Vritra was a ferocious opponent. For a while, Indra seemed to be losing the fight, as the huge serpent wound about him in suffocating coils.

But then, Vritra made a big mistake.

For one brief moment, he took his eyes

off his victim. Indra saw his chance.

Quick as a flash, he fired one of his thunderbolts.

It pierced through Vritra's heart and killed him.

 As he rolled, lifeless, down the mountainside,

the great dragon burst apart, releasing the heavenly waters.

New rivers gushed and tumbled down to the sea. Indra's sun

chariot rose in the sky, and the first dawn broke over a new world.

HERACLES AND THE HYDRA

Heracles, sometimes called Hercules, is a hero of ancient Greek and Roman legend. This is one of many stories about him.

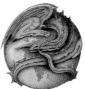

Heracles was the human son of Zeus, king of the gods. He was born with supernatural strength. While still a baby, he strangled some serpents that attacked him in his cradle. As a boy, he killed a lion that attacked his family's herd of sheep.

Like many young men, Heracles married and became a father. But one day, in a terrible fit of madness, he killed all his children. Horrified by what he had done, Heracles fled to a place called Argolis. There Eurythmus, the ruler of Greece, ordered Heracles to do twelve almost impossible labours as punishment for his crime. One of these was to kill the Hydra, a hideous dragon with nine heads.

Each night the Hydra left its murky den in the swamps to massacre the animals and ruin the crops of the local farmers. But everyone who tried to kill the Hydra failed. As soon as they chopped off one of its heads, another grew in its place. Not only that, the breath of the Hydra was so foul and deadly that anyone who breathed its fumes immediately fell down and died.

With his friend Iolaus, Heracles set out to kill the Hydra. Soon they came to a spring of clear, fresh water. Somewhere nearby, the Hydra lay hiding. Heracles shot several flaming arrows into the air to bring the Hydra out into the open. Suddenly the Hydra appeared, eyes blazing wickedly in each of its nine heads. Heracles took a deep breath, lifted his heavy club and attacked.

Thwack! Down came the club and knocked off one of the Hydra's heads. The dragon roared with rage. Heracles brought down the club again and again, but each time a head fell, another grew back in its place. The task seemed impossible.

"What can I do?" he called to his friend.

Iolaus had an idea. He lit a torch and thrust it into Heracles' hand.

"Each time you strike off a head," he shouted, "scorch the stump with this flame!"

With renewed strength, Heracles returned to battle. Thwack! A head fell. Sssst! The flame sizzled against the bloody stump. One by one the heads fell. None grew back. The Hydra was defeated.

The last of the Hydra's heads was believed to be immortal, so Heracles buried it beneath a giant rock, where it could cause no harm.

Then he dipped his arrows in the Hydra's poisonous blood.

He would be well-armed for future adventures.

CADMUS AND THE GOLDEN DRAGON

The Greek hero Cadmus founded the royal city of Thebes,
where many of the ancient Greek and Roman legends took place.

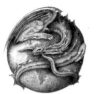

When the king of Phoenicia's daughter went missing, he sent his son Cadmus to search the world for her. But though he and his companions travelled far and wide, Cadmus failed to find his sister. So he went to the famous Oracle at Delphi to ask what he should do. The Oracle's advice puzzled Cadmus. She advised him to forget his sister, for he would never see her again. Instead, he should follow a sacred cow that he would find outside the temple. He was to follow the cow until she lay down to rest. On that spot he was to build a city.

Cadmus and his companions did as they were told, and followed the cow as she wandered over the hills. At last she lay down in a circle of shady trees. The thirsty travellers could hear the refreshing sounds of a nearby spring. Cadmus sent his companions to fetch water. He sat on the soft grass and waited, but his friends never returned. After a while, Cadmus went to see what had become of them. Close to the spring, he found them. They were all dead, their bodies torn and covered with blood. Cadmus looked up to see drops of blood dripping to the ground.

Towering over him was a huge, golden dragon with three rows of razor-sharp teeth.

Instantly Cadmus drew back his spear and plunged it far into the monster's flesh. To his horror, it did not die. Instead the creature uncoiled and moved towards him, fire flaring from its nostrils. Cadmus fell back as the creature attacked.

Cornered and desperate, Cadmus thrust his spear past the three rows of teeth, deep into the dragon's belly. Black blood spewed from the monster's mouth as it twisted and convulsed in pain. Before it could make one last frenzied attack, Cadmus heaved up an enormous rock and crushed the creature's skull.

Then Cadmus heard a voice in his head say, "Plant the teeth of the dragon you have slain." So he wrenched the teeth from the creature's enormous jaws and buried them deep in the soil. At once the ground started to heave, and from the earth sprouted a crop of fully armed soldiers! Cadmus was afraid the soldiers would attack him, so he tossed several stones to confuse them and make them turn on one another. They fought so furiously that soon only five were left alive. Then one of them said, "Brothers, stop! Before all is lost, we must end this foolish bloodshed, and change our fate." So they laid down their weapons and accepted Cadmus as their new leader.

The next day they buried Cadmus' friends and held a meeting. Together they pledged to help Cadmus build his city, as the Oracle had told him to. The city, called Thebes, became great. Cadmus ruled over it for many years.

PRINCE SIGURD AND THE DRAGON FAFNIR

This Northern myth was told in verse by travelling storytellers long before it was written down in the thirteenth century.

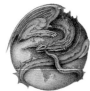

Prince Sigurd had a powerful sword. It had been given to his father by Odin, god of wisdom and war. The prince planned to use the sword to slay a mighty dragon named Fafnir. The dragon lived in a dark cave, surrounded by a glittering hoard of treasure.

Sigurd's guardian, an evil dwarf named Reginn, was greedy for the treasure in Fafnir's cave. Reginn secretly hoped that both the dragon and Sigurd would die, so that he could have all the treasure for himself.

The prince and Reginn set off for the dragon's cave. Pressed into the earth in front of it were enormous fresh footprints. Sigurd felt a stab of fear. Fafnir was far larger than he had expected.

But Reginn had a plan for dealing with the dragon. He told Sigurd to dig a deep pit across the path to the river, where the dragon came each morning to drink. "Then hide in the pit and wait for the dragon to come."

As Sigurd dug, an old man mysteriously appeared beside him. "Young Prince," he said, "you must dig a shallow pit by the side of the one you dig now. Crawl into the shallow pit when Fafnir's blood begins to flow, so you will be safe from its burning power. Be warned, for though your guardian knows the blood is deadly, he did not tell you."

Before Sigurd could reply, the old man vanished. Sigurd believed that the old man was the god Odin in disguise, so he dug a second pit beside the first, as he had been told.

In the cool dawn, Sigurd crouched in the deep pit, sword poised ready to plunge. The ground shuddered as Fafnir lumbered towards the river. Sigurd held his breath. Then, as the dragon passed over the pit, Sigurd thrust the sword deep into its body. As the burning blood began to pour from the dragon, Sigurd slid safely into the shallow pit. Above him, Fafnir writhed in pain and lashed out with his head and tail. But the wound was fatal, and soon Fafnir was dead.

Reginn was astonished to see Sigurd still alive, but he ran to congratulate the prince. "Cook me the dragon's heart," he said, "and I shall eat it in your honour." As Sigurd cooked the heart, some of the juices ran onto his hands. Without thinking, Sigurd licked his fingers. Suddenly he could understand the language of the birds. He listened in wonder as they told him that if he ate the heart himself he would become the wisest of men. Then the birds told Sigurd that Reginn was planning at that very moment to kill him and steal the treasure for himself.

So Sigurd swung out with his sword once more and chopped off Reginn's head, then ate the dragon's heart. He became the wisest of men, and claimed the treasure he had so bravely fought for.

BEOWULF AND THE FIRE DRAGON

Tales of the exploits of Beowulf were brought to England by storytellers from Scandinavia. Beowulf's adventures were first written down in English in the eighth century.

 Beowulf was a true hero. In his youth, he had slain three terrible monsters. Then he had become king of the Geats, and had ruled wisely for fifty years. His final battle was with a fearsome fire dragon, and it came about in this way.

One day, one of Beowulf's servants ran away because he was in trouble. Looking for somewhere to hide, he accidentally discovered a remote burial mound on a rocky cliff above the sea. The servant stepped inside. As his eyes adjusted to the darkness, he made out a faint light glimmering in the distance. He moved towards it but stopped in his tracks as he realised it was the fiery glow from a dragon's nostrils.

The creature lay fast asleep upon a bed of golden rings, goblets and bowls, surrounded by a glittering heap of silver swords, jewel-encrusted helmets, and coins. Thinking that just one piece of treasure would buy him out of trouble, the servant stole a golden goblet. He crept silently from the mound and ran back home with it as fast as he could.

When the dragon awoke that night, it immediately noticed that it had been robbed. Angered, the fire-breathing monster swept down from the mound to take its revenge. It flew the length and breadth of Beowulf's kingdom, setting fire to farms and villages.

Although Beowulf was now an old man, he realised that he alone could rid his people of the terrible fire dragon.

With a small band of warriors, the king set out to the burial mound, led by the disgraced servant. As they drew near, Wiglaf, the youngest in the party, begged to go and fight alongside his master, but Beowulf chose to face the dragon alone. At the entrance, Beowulf called out, "Dragon, come forth and face your destroyer!" He raised his iron shield against the dragon's fire and charged towards his enemy. The old king struck out with his sword, but the blade bounced off the dragon's horny head. Beowulf's face was blackened by fire and his hair stood ablaze. He struck again and again, but his sword cracked, then shattered in his hands. He reached for his dagger, but he was too late to stop the dragon's poisonous fangs from ripping his neck. Just then, Wiglaf rushed to the king's side and jabbed his sword into the flesh below the monster's jaws. Immediately the dragon's fire weakened.

Together, Beowulf and Wiglaf hacked at the dragon's hide until the beast collapsed before them and died. But in those few moments the poison had taken hold of the old king's life. Anxious to please him, young Wiglaf ran into the mound and brought out armfuls of the dragon's hoard. As his life slipped away, Beowulf gave his own helmet and golden ring to Wiglaf, and with his last breath told his bravest follower, "Now you shall take my place as king of the Geats."

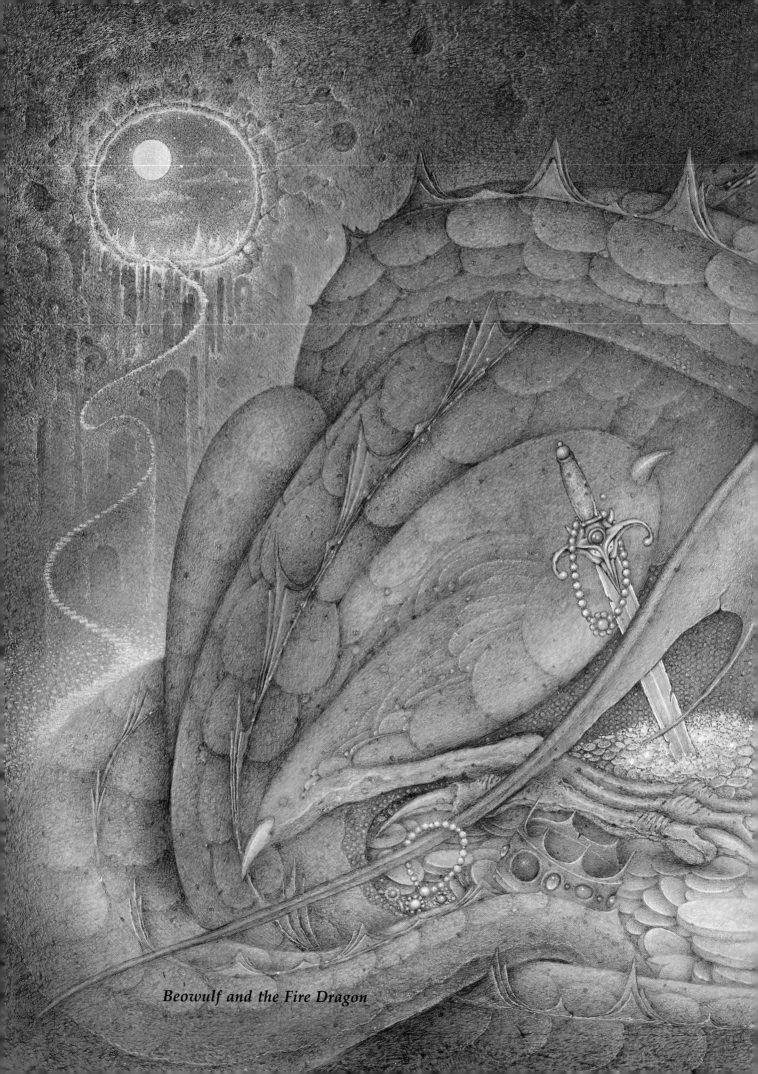

Beowulf and the Fire Dragon

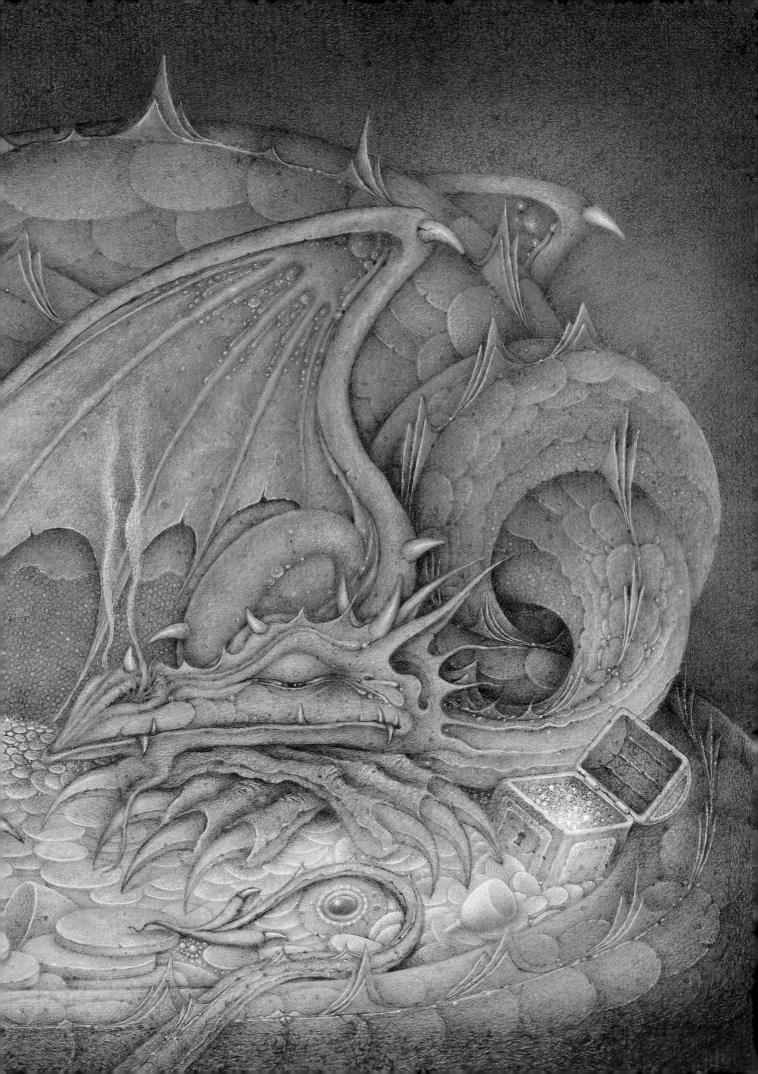

SAINT GEORGE

Saint George is the patron saint of England. He was born in Eastern Turkey about 1,700 years ago. This story about him was told to demonstrate the power of Christianity over evil. It was first written down in the sixth century.

George was a Roman soldier in the Emperor's Imperial Guard. When the Emperor passed a law stating that all the Christians should be killed, George was horrified. He immediately left the Roman army and took up the Christian faith himself. George travelled back to his birthplace, Cappadocia in Turkey.

He put on a suit of silver armour with the sign of the Cross on his buckle and shield. Then, riding a horse harnessed in gold, George set out to seek adventure and spread the Christian faith.

It so happened that a monstrous dragon was on the rampage in the Libyan city of Silene. It had come down from the bleak hills and made its home in a large lake on the outskirts of the city.

The dragon fed on the sheep and cattle that grazed on the hills. But one day, the mangled remains of a shepherd boy were found. From that time on, the dragon came right up to the city gates in its search for food. Soon the only way to keep it away was to leave two sheep every day by the lake. But eventually there were no sheep left to give the dragon.

The city council met and came to a dreadful decision. The dragon would have to be fed with children. Names would be drawn each day to see which child should be left beside the dragon's lake. One day, the lot fell to the king's daughter. He pleaded for her life, but it was no use. The princess, dressed like a bride, was tied to a rock near the dragon's lake.

As the princess was waiting for the dragon to appear, George rode by on his horse. He prepared to rescue her, but she told him to ride on or the dragon would kill him too. George refused to go. He said, "In the name of Jesus Christ, I shall save you from this dragon!" George rode down to the water's edge, and when the huge, scaly monster emerged, he steadied his horse and charged. In one forceful thrust, his lance pierced the dragon's belly. Immediately the fight went out of the dragon.

George told the princess to tie her silken belt around the dragon's neck, and together they led it back to the city.

The people of Silene were amazed to see the wounded dragon. George told them that it was Christ the Lord who had delivered them from this evil. The king and all his people were baptised into the Christian faith. Then George chopped off the dragon's head. It took four cartloads to carry away the monster's bloody remains from the city.

Some say the princess and George were married. According to history, George was later tortured and killed for his faith. But 800 years after his death, when Christians went on Crusades, George was made a saint.

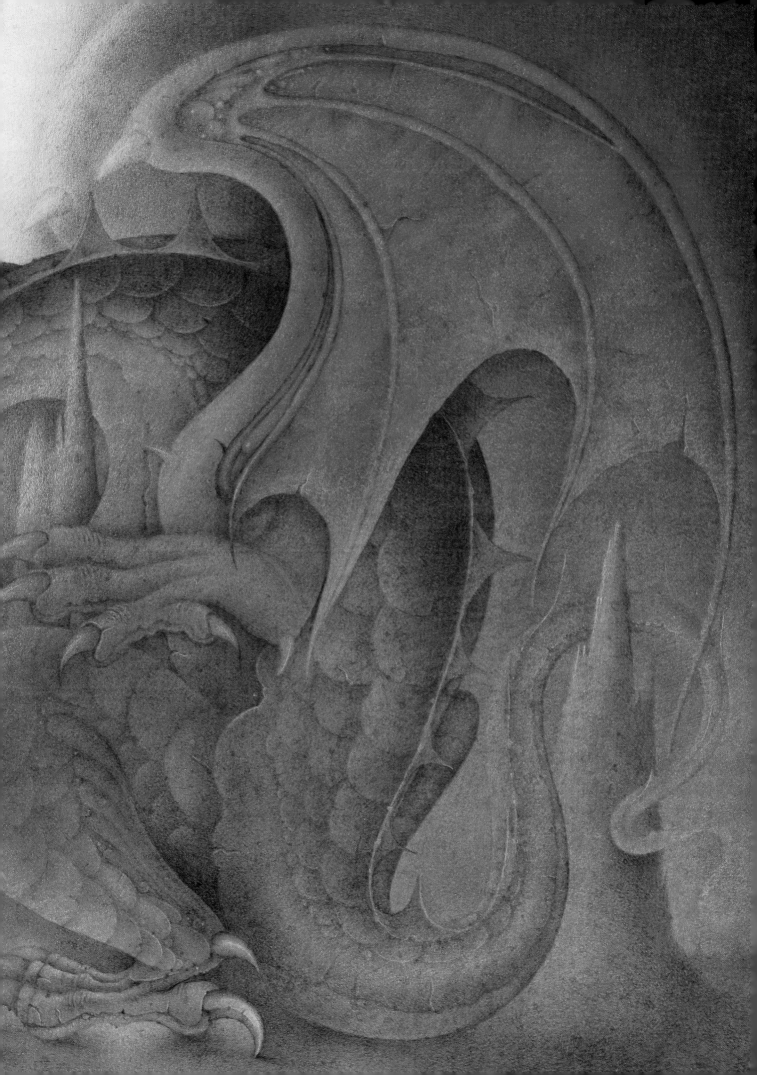

THE LAMBTON WORM

This folktale lives on in the place names of the area in
County Durham – Worm Hill and Worm Well.

The heir to Lambton Hall was a lazy and irresponsible fellow
who liked nothing better than to fish for salmon in the River
Wear. One Sunday, when everyone else was at church, Lambton hooked
an evil-looking worm from the river. "It looks like the devil itself," said
a passing stranger. But on his way home Lambton tossed the worm
down the village well and thought no more of it.

The years passed. Young Lambton grew out of his idle ways and left
home to fight in the Holy Crusades. Meanwhile, still hidden at the
bottom of the well, the worm continued to grow. One day, to the
horror of the villagers, the terrible worm crawled out of the well and
made its way to the River Wear. By day it wound itself around a rock in
the water, and at night it slept coiled ten times around a neighbouring
hill. As it grew ever larger, the worm became the terror of the
countryside, with a hideous hunger for man, milk and beast.
One day, it crossed the River Wear to Lambton Hall. But,
on the advice of the head servant, the household was
prepared. The largest horse trough in the castle yard
had been filled to the brim with milk. The worm
drank its fill and slithered away.

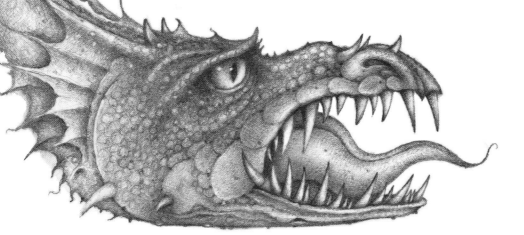

Every day the worm came back to Lambton Hall for more. One drop less than usual and the wicked worm wound its tail round the trees and tore them from the ground.

The household suffered seven years of this daily ritual. Then young Lambton returned home from the wars. He realised with dismay that this was the same worm that he had thrown down the well years before. So he went to the local witch for advice. She told him to go and fight the worm, wearing a suit of armour studded with spikes. She added that once the worm was dead, Lambton must kill the next living creature he saw. Otherwise a terrible curse would fall upon his entire family.

Lambton did just as he was told. As the worm wound itself around him, his armour started to crack, but the spikes sank into the creature's skin and its blood gushed forth. As the worm squeezed ever more tightly, its body was cut apart. Piece by piece, it fell into the rushing river. When only the head remained, the worm's eyes flashed fiercely at Lambton before vanishing into the water.

Lambton looked up – and to his horror the first living creature he saw was his father. Of course, he could not kill his own father. So the next nine generations of the Lambton family were doomed to die in battle or abroad, never in their own bed. The worm had got its revenge.

THE MORDIFORD WYVERN

A wyvern was a two-legged, winged dragon. Records from 1607 mention
a painting of a wyvern on the church wall in the English village
of Mordiford. This is a local folktale about the dragon.

Maud was a child who loved to wander in the woods near her home and make friends with wild animals. One particular day she discovered a strange animal lying fast asleep in the woodland grass. It was no bigger than a cucumber, with folded wings and skin that sparkled like sequins. Maud gently touched the creature, which instantly fluttered into the air. After many attempts, she managed to lure it down with a saucer of milk. The baby wyvern – for that is what it was – licked the saucer clean and then crawled affectionately into her arms. Unaware of what she had found, Maud took the creature home. When her father saw it, he became fearful and told Maud to put the creature back where she had found it. But Maud disobeyed and kept her pet secretly in a small cage at the bottom of the garden.

Each day as Maud innocently fed the wyvern milk, its evil nature grew. Eventually it broke out of its cage and flew back to the woods. At first the wyvern lived on rabbits and squirrels, but it soon grew fond of cattle and sheep. Then one day it devoured a plump young shepherd boy as he slept beside his sheep.

Day by day, as more people were eaten, the village farmers feared for themselves and their families. The only person who seemed safe was Maud, perhaps because the wyvern remembered her kindness. But even Maud became afraid as the monster kept on killing.

Every attempt to destroy the dragon failed,

until one day a prisoner called Garston offered to try.

He was condemned to die, but the judge promised to

free him if he could rid Mordiford of the terrible monster.

Garston built a barrel spiked with deadly hooks and blades. He placed

the barrel in the wyvern's path, then crawled inside. As the wyvern drew

near, it stopped. The smell of human flesh made the monster drool.

The dragon coiled its powerful flanks around the spiky container.

Using all its strength, it tried to crush the barrel and get at Garston. But

the harder it squeezed, the more blood poured from its scaly skin. Inside

the barrel, Garston grew hot and breathless. Through a peephole he

watched the wounded wyvern's fiery breath set fire to bushes and trees.

Suddenly the barrel began to crack. Garston fired his pistol through

the peephole again and again. The wyvern writhed in pain, uncoiled,

and fell to the ground. Flushed with success, Garston jumped from the

barrel and began to hack off the monster's head. But as he chopped, he

breathed in the last poisonous fumes of the dying dragon's

breath and fell, lifeless. Garston was dead, but so was

the wyvern. It would never again terrify

the villagers of Mordiford.

THE GAOLIANG BRIDGE

*Like many Chinese dragons, the one in this story rules over water
and is able to change its shape at will.*

Centuries ago in China, in the place where the city of Beijing
now stands, the land was poor and marshy. A powerful dragon
and his family ruled over the marsh, and the land belonged to them.

The Emperor Ming wanted to build a great city on the dragon's land.
He was encouraged in his plan by a god named Nocha.

The dragon watched angrily as workers began to build the new city.
In revenge, the dragon decided to deprive its people of all their precious
sources of water. He changed himself and his wife into a harmless old
man and woman with a handcart containing two large water jars.
Then he appeared before the Emperor in a dream.

In the dream, the old man and the old woman asked the Emperor for
permission to take their water jars out of the city. Unaware that the jars
contained all the waters of the entire region, the Emperor said,
"Of course. Take the jars with my blessing."

When the Emperor woke the next morning, he heard people crying out that all through the kingdom the water supply had totally dried up.

The god Nocha understood what had happened, but he was unable to stop the dragons appearing in the Emperor's dream. So he himself appeared in a dream to Liu Bowen, the city's chief architect. In the dream, Nocha told Liu Bowen what he must do to bring back the missing water. First, Liu Bowen sent messengers to all the city gates to find out who had left the city during the night. When he heard that the old man and woman had taken their handcart out through the west gate, he knew he had to act quickly. The road to the west was the road that led to the sea. The jars had to be destroyed before the dragons reached the sea, where the city's water would be lost for ever.

Liu Bowen asked for a brave soldier to volunteer for the dangerous task. Only one stepped forward. His name was Gaoliang. Liu Bowen handed him a lance with which to break the jars. "Catch up with the cart as silently as you can," he said. "Pierce both jars and ride back quickly to the city. Do not turn around. Do not look back!"

Gaoliang took the lance and sped away.

Soon he spotted the dragons in their disguise. He carefully crept up close and shattered one of the jars. But before he could break the other one, the water from the first gushed out with such force that it threatened to drown him. At the same moment, a thunderous crash rippled through the sky as the old man transformed himself back into a dragon. Although his mission was only half complete, Gaoliang had no choice but to flee back to the city.

The roar and rumble of the water followed Gaoliang all the way home. As he neared the city gates, Gaoliang felt he must be safe. Then he saw Liu Bowen staring over his shoulder. Gaoliang forgot his orders and turned around. A huge wave swept over him, and he was drowned.

A bridge was built just outside the city to honour the soldier who had so bravely tried to save it. The Gaoliang Bridge stood until quite recently.

The jar that Gaoliang did not shatter was said to contain all the city's sweet spring water. Since then, sweet water has been found only on the hill where Gaoliang caught up with the dragon. The place is called the Hill of Jade Springs. But the water that came back to the city from the broken jar has remained bitter, even to this day.

THE CHINESE DRAGON'S PEARL

*A Chinese dragon carried a bright pearl of great power and value
under its chin or inside its throat.*

Long ago, in China, a young boy and his mother lived
in a small village by the banks of the Min River. The boy
earned what little money he could by cutting fresh grass and selling it to
the villagers to feed their animals.

One summer there was a terrible drought. The boy had to travel
farther and farther to find grass that wasn't dry and brown. At last, many
miles from the village, he came across a patch of lush green grass. He cut
as much as he could carry and hurried all the way home to sell it.

Day after day he went back to the same place, where the grass seemed
always to spring up again, strangely bright and green.

After a while the boy grew weary of so much walking. He decided to
dig up some of the grass and plant it near his home. He set out
with a spade and dug himself a nice square of turf.

To his great surprise, when he lifted the earth
an enormous gleaming pearl rolled out!
The boy pocketed the pearl, shouldered his
spade and carefully carried home his square
of grass. He planted the grass, then showed
the pearl to his mother.

"This pearl is worth a great deal of money," she said, and hid it
for safe-keeping in an almost empty rice jar.

Next morning the boy was saddened to find that his grass had
shrivelled up and died.

"Never mind," said his mother. "Our pearl will buy us food."
And she opened the lid of the rice jar. To her amazement, it was
brimming with grains of rice. She looked at her son. Both of them
realised at once that the pearl was magic. So that night, they placed the
pearl on top of the last three coins in their money jar. By morning, the
jar was full of bright, shiny coins.

The boy and his mother told no one about the pearl, but soon it
became obvious to other people that they were growing richer and
richer. One day robbers broke into the house. The boy looked
on in horror as they came close to the pearl's hiding place.
In panic he grabbed the pearl from the jar, popped it
into his mouth and swallowed it! As the pearl
made its way down to the boy's belly, his
insides began to burn.

He ran to the nearby well and poured whole buckets of water down his throat, but still the fire raged. He rushed to the river and gulped down more and more water. Then before his mother's eyes, the boy began to swell. His body shook. His skin cracked and became scaly. He sprouted horns and wings. The boy had become a dragon.

As the new dragon dived into the river, the heavens opened and rain poured on to the dried-up land. The horrified mother cried out to her son. Frantically he twisted and turned to look back at her. The great coils of his scaly body lashed back and forth in the rushing water, causing mud from the bottom of the river to be pushed up into huge banks.

The mud banks are still there today. They are called the "Looking Back at Mother" banks.

Dragons Around the World

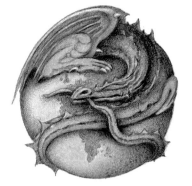

At one time or another, stories about dragons have been told in most countries of the world. As the pictures in this book show, not all dragons have four legs, clawed feet and wings. They come in many different shapes, colours and sizes. Some dragons are part of local folklore or a national legend. Others appear as isolated reports in monastic records or in an early naturalist's notes. What follows is a selection of dragons from around the world.

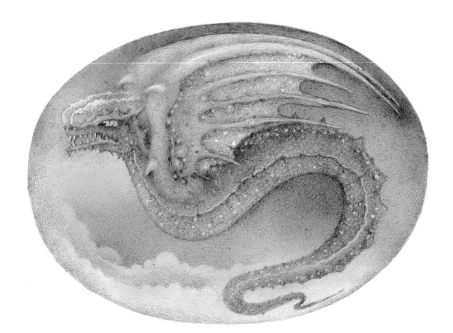

The Amphiptère (America, North Africa, Europe)
Amphiptères were legless winged dragons, or flying serpents. They were first seen in ancient Egypt, where great swarms guarded the frankincense trees. The most beautiful account describes them in the woods around Penllyne Castle in Wales. They had eyes like the feathers in a peacock's tail and wings that sparkled and glittered wherever they flew.

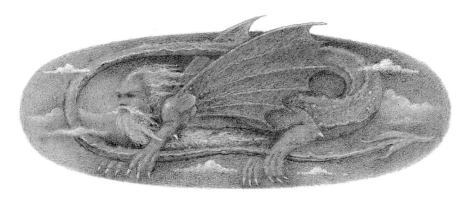

The Piasa (North America)

The Algonquin Indians of North America worshipped a dragon with the face of a man and a tail so long that it passed over its body and head, and between its legs. An ancient 'life-sized' painting of the dragon once existed on Piasa Rock in Illinois, but it was unfortunately blown up by workers quarrying for stones. In the Algonquin language, *piasa* means 'man-eating bird'.

The O-Gon-Cho (Japan)

The O-Gon-Cho was a white dragon that lived in a deep pond at Yamashiro. Every fifty years the dragon rose from the pond and took flight as a golden-feathered bird. Its howl warned people of impending disaster.

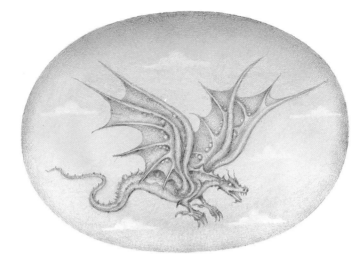

The Ethiopian Dream (Africa)

This dragon had four wings and clawed feet. It was large enough to kill elephants and often ate poisonous plants that made its bite more deadly. Four or five of these dragons were once reported to have twisted themselves together like willow branches and sailed across the sea to find fresh food supplies in Arabia.

The Tarasque (France)

The Tarasque was half-fish, half-animal. It lived in a forest near the River Rhône, where it sank boats and devoured the passengers. The local inhabitants prayed to St Martha, who was famous for performing miracles. She held out her cross before the Tarasque and sprinkled it with holy water. Cowering before such a force for Good, the Tarasque was led to a nearby village, now named Tarascon, where it was put to death by the villagers.

The Amphisbaena (Africa)

This dragon had a head at each end and could move in either direction. While an Amphisbaena's eggs were hatching, she could keep one head awake at a time to watch over them. Today there is a South American limbless lizard that gives the impression of having two heads. When threatened, it raises its tail and moves backwards and forwards.

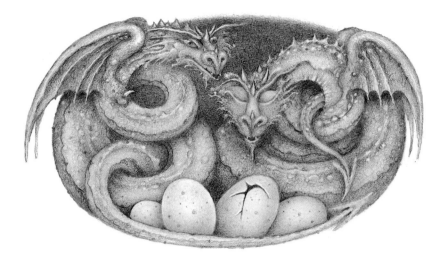

The Midgard Serpent (Scandinavia)

The Midgard Serpent of Scandinavian mythology was so long that it slept in the sea with its tail in its mouth, and its body encircled the world. According to the myth, Midgard will wake at the end of the world and be killed by Thor, god of war and thunder, who will also die in the struggle.

The Chinese Dragon or 'Lung' (China)

Chinese dragons laid their eggs on the banks of rivers or lakes. The eggs looked like beautiful stones and took a thousand years to hatch. When the first crack appeared in an egg, the parents both called out. The father's cry whipped up the winds, and the mother's cry calmed them. Thunderstorms and drenching rain rocked the world as the egg burst open and the young dragon was born. It took fifteen hundred years to become a full-grown 'lung', another five hundred to grow horns and a thousand more to develop wings.

There were four main kinds of 'lung'. The Tien-lung (Celestial Dragon) held up the palaces of the gods; the Shen-lung (Spiritual Dragon) controlled the wind and rain; the Ti-lung (Earth Dragon) ruled the rivers and streams; and the Fut's-lung (Subterranean Dragon) guarded treasure and precious metals.

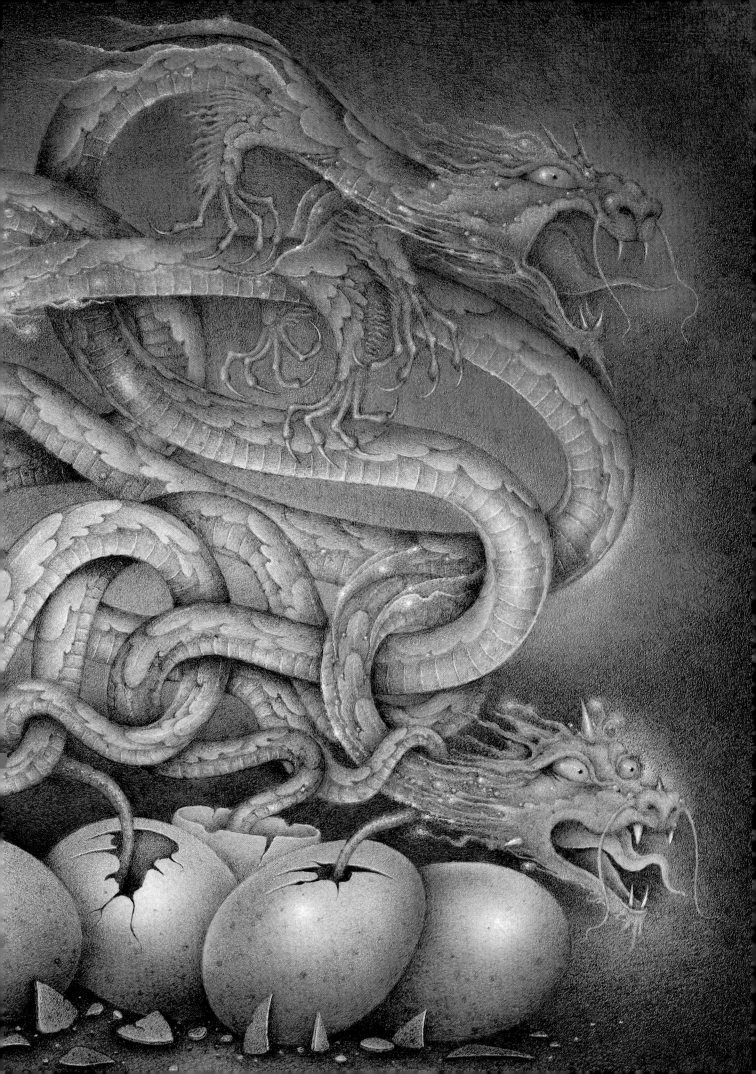

DRAGON POEM

by H.D.C. Peplar (1916)

Child

Are all the dragons fled?

Are all the goblins dead?

Am I quite safe in bed?

Nurse

Thou art quite safe in bed.

Dragons and goblins all are dead.

Child

When Michael's angels fought

The dragon, was it caught?

Did it jump and roar?

(Oh Nurse, don't shut the door.)

And did it try to bite?

(Nurse, don't blow out the light.)

Nurse

Hush, thou knowest what I said,

Saints and dragons all are dead.

Father (to himself)

O Child, Nurse lies to thee,

For dragons thou shalt see.

Please God that on that day

Thou may'st a dragon slay;

And if thou dost not faint,

God shall not want a Saint.

INDEX

More fun books for you to read!

ALICE'S Adventures in Wonderland
Lewis Carroll
Illustrated by Michael Foreman

ISBN 1 84365 056 8

The Star Child

ISBN 1 84365 012 6

ebby meets Felicity
Matt Hickey
Illustrated by Christopher Corr

ISBN 1 84365 061 4

The Princess and the Rainbow Coat

ISBN 1 84365 024 X

Princess Stories From Around the World

ISBN 1 84365 025 8

GIANT TALES
Retold by Fiona Waters
Illustrated by Amanda Hall

ISBN 1 84365 017 7